* .	
,	
•	
* 1	
,	

DRAW 50 ENDANGERED ANIMALS

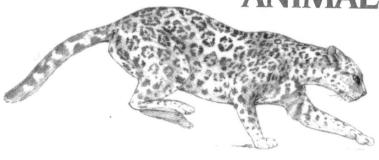

BOOKS IN THIS SERIES

Draw 50 Airplanes, Aircraft, and Spacecraft

Draw 50 Aliens, UFOs, Galaxy Ghouls, Milky Way Marauders, and Other Extraterrestrial Creatures

Draw 50 Animal 'Toons

Draw 50 Animals

Draw 50 Athletes

Draw 50 Beasties and Yugglies and Turnover Uglies and Things That Go Bump in the Night

Draw 50 Birds

Draw 50 Boats, Ships, Trucks, and Trains

Draw 50 Buildings and Other Structures

Draw 50 Cars, Trucks, and Motorcycles

Draw 50 Cats

Draw 50 Creepy Crawlies

Draw 50 Dinosaurs and Other Prehistoric Animals

Draw 50 Dogs

Draw 50 Endangered Animals

Draw 50 Famous Caricatures

Draw 50 Famous Cartoons

Draw 50 Famous Faces

Draw 50 Flowers, Trees, and Other Plants

Draw 50 Holiday Decorations

Draw 50 Horses

Draw 50 Monsters, Creeps, Superheroes, Demons, Dragons, Nerds, Dirts, Ghouls, Giants, Vampires, Zombies, and Other Curiosa . . .

Draw 50 People

Draw 50 People of the Bible

Draw 50 Sharks, Whales, and Other Sea Creatures

Draw 50 Vehicles

DRAW 50 ENDANGERED ANIMALS

Lee J. Ames with Warren Budd

BROADWAY BOOKS New York

Published by Broadway Books a division of Random House, Inc. 1540 Broadway, New York, New York 10036

Broadway Books and its logo, a letter B bisected on the diagonal, are trademarks of Broadway Books, a division of Random House, Inc.

Library of Congress Cataloging-in-Publication Data Ames, Lee J.

Draw 50 endangered animals / Lee J. Ames with Warren Budd.

p. cm.
1. Animals in art. 2. Endangered species in art. 3. Drawing—
Technique. I. Budd, Warren. II. Title. III. Title: Draw fifty
endangered animals.

NC780.A484 1993 743'.6—dc20 93-25334

CIP

ISBN 0-385-46985-3

Text and Illustrations © 1992 by Lee J. Ames and Murray D. Zak

All Rights Reserved

Printed in the United States of America

October 1993

20 19 18 17 16 15 14 13

This book is dedicated, with deep concern, to us all. For we, too, are endangered.

To the Reader

To be able to see, and for the most part, to have enjoyed what I've been able to see, has filled my life with constant pleasure. Being able to reproduce, by drawing, what I see, or what I visualize in my imagination, adds even more satisfaction. Being able to show others, like yourselves, how to construct a drawing, tops it all.

In this world of glorious things to see, some may not be with us for long. Among these are many wonderful living creatures. These are the endangered animals with whom, as long as we've existed, we've shared this earth. Let's learn to draw these friends before they may leave us forever.

Warren Budd, whom I've known and worked with for many years, did a lion's share of the research and the art for this book. I've watched him develop from a raw, insecure art school student to the accomplished artist with whom I'm delighted to share coauthorship.

When you start working I suggest you use clean white bond paper or drawing paper and a pencil with moderately soft lead (HB or No. 2). Keep a kneaded eraser handy (available at art supply stores). Choose the subject you want to draw and then, very lightly and very carefully, sketch out the first step. Also very lightly and carefully, add the second step. As you go along, study not only the lines but the spaces between the lines. Size your first steps to fill your drawing paper agreeably, not too large, not too small. Remember, the first steps must be constructed with the greatest care. A mistake here could ruin the whole thing.

As you work it's a good idea, from time to time, to hold a mirror to your sketch. The image in the mirror frequently shows distortion you may not recognize otherwise.

You will notice that new-step additions (in color) are printed darker. This is so they can be clearly seen. But remember to always keep your construction steps very light. Here's where the kneaded eraser can be useful. You can lighten a pencil stroke that is too dark by pressing on it with the eraser.

When you've softly sketched all the light steps, and you're sure you have everything the way you want it, finish your drawing with firm, strong penciling.

If you like, you can go over your drawing with India Ink (applied with a fine brush or pen), or a permanent fine-tipped ballpoint or felt-tipped marker. When thoroughly dry, you can then use the kneaded eraser to clean off all the underlying pencil marks.

Remember, if your first attempts at drawing do not turn out the way you'd like, it's important to keep trying. Your efforts will eventually pay off and you'll be pleased and surprised at what you can accomplish. I sincerely hope you'll improve your drawing skills and have a great time recording drawings of our endangered friends.

An Additional Note

As a preteen student in New York City's public school system, I did well enough. During the drawing periods, however, I had an edge. Drawing classes were relaxed and, for the most part, easy fun. There, I was better than average. There, I was able to do what I most loved. The approval I received encouraged me to avidly pursue further drawing skills. In addition, that pleasant time carried over and enhanced my entire school experience. Then, while I was in the sixth grade, in the middle of the school term my family moved to another borough of the city. I was enrolled in a new school.

A difficult time followed. Some of the courses were entirely different; the new way of teaching familiar subjects had me totally confused. It all seemed so overwhelming, what with new kids, no friends, and a great deal of homework to catch up on.

There was, however, something to look forward to . . . a drawing period on Friday afternoon! Now, I would have a chance to display what I could do best. Now, I might receive friendly, favorable recognition.

Finally Friday came. But just as the drawing period was about to begin, the teacher brought another student's history notebook to my desk. "Here," she said, "you can spend this time copying Robert's notes into your notebook. Drawing is not that important."

Three unpleasant weeks followed. Then I had an incredible stroke of luck! My parents were notified that I'd been placed in the wrong school district. I was transferred to another school, Public School 12 in the borough of Queens. At P.S. 12, drawing class was considered important. There, I began to experience wonderful things.

Not only did this school regard the drawing class as important, but the teacher understood the significant value of encouraging each and every student.

We were permitted to invent, to explore, to copy. Being allowed to "copy" was unusual then. That teacher, I feel, was way ahead of her time. Copying permitted me to explore many different kinds of drawings and ways to draw. It also helped me develop the necessary drawing muscles enabling me to hone my skills.

Mimicry and copying, I find, are prerequisites to creativity!

It is my hope that you will be able to come up with drawings that will bring gratifying approval from friends and family. After that I look forward to the competition.

LEE J. AMES

DRAW 50 ENDANGERED ANIMALS

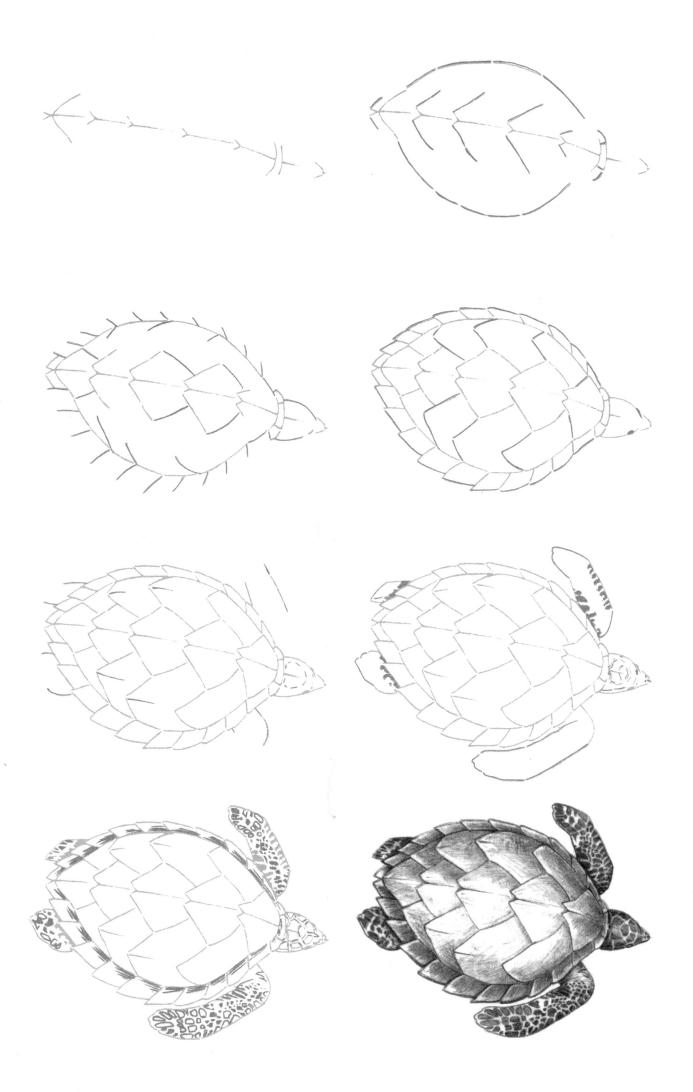

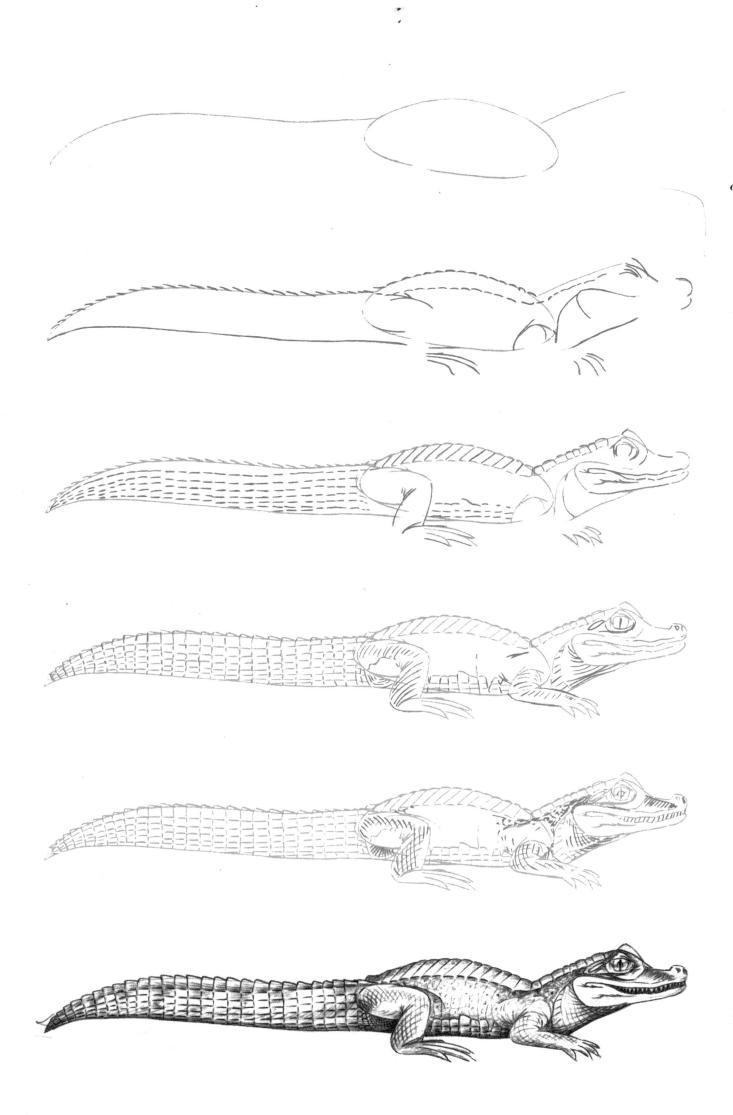

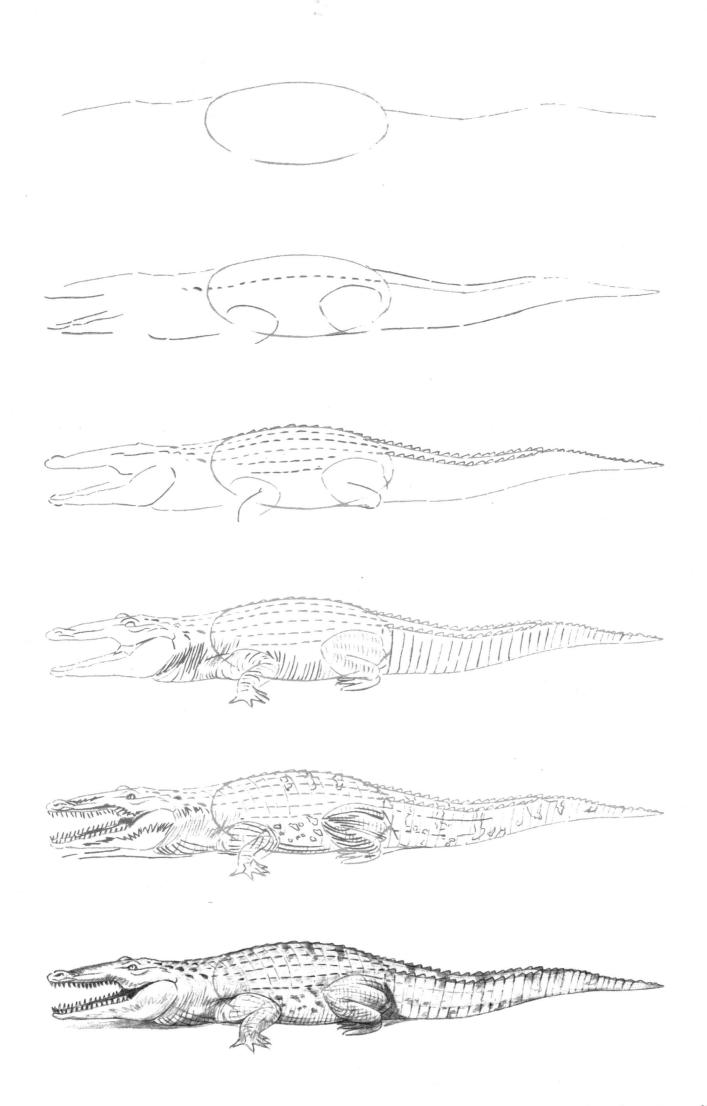

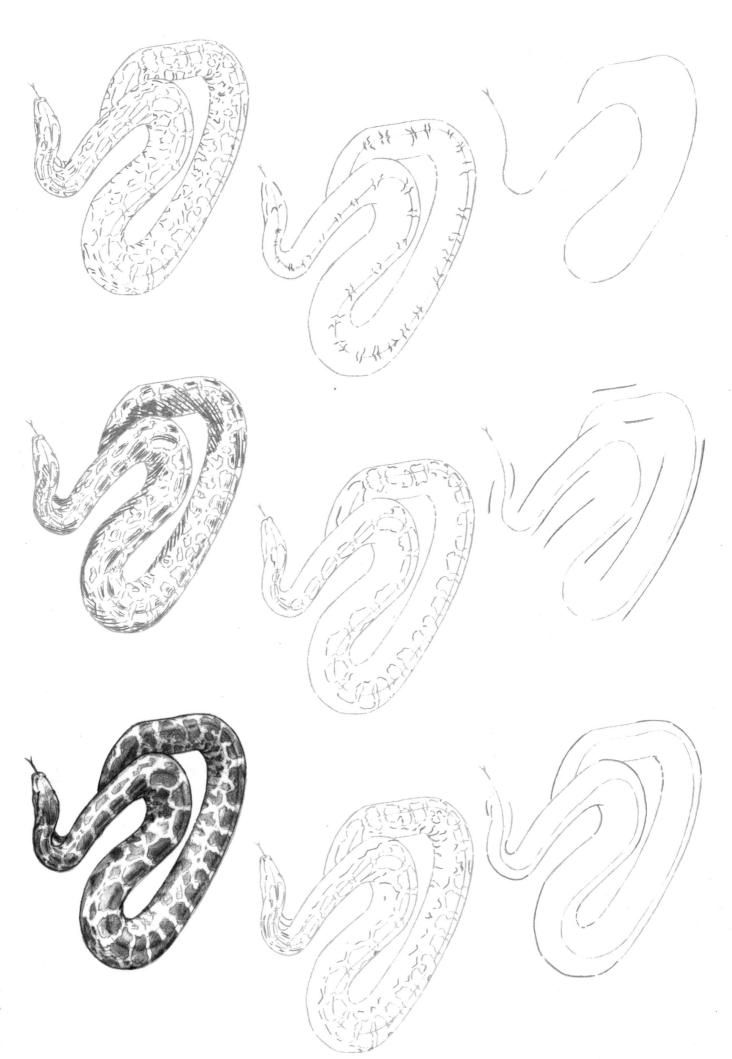

Thin-Spined Porcupine

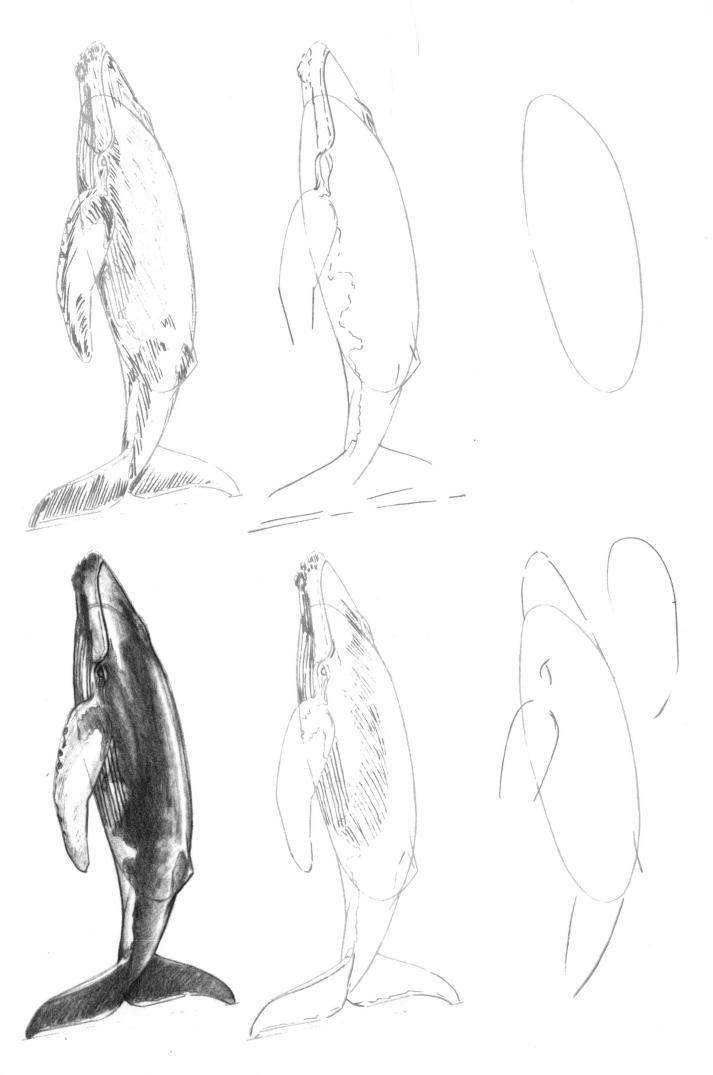

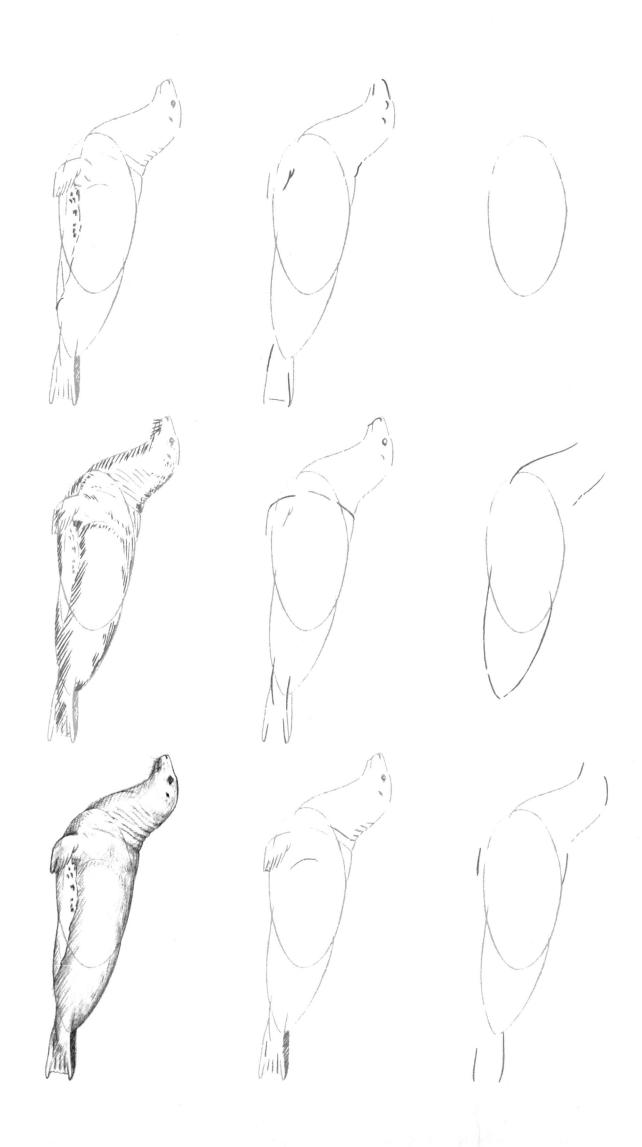

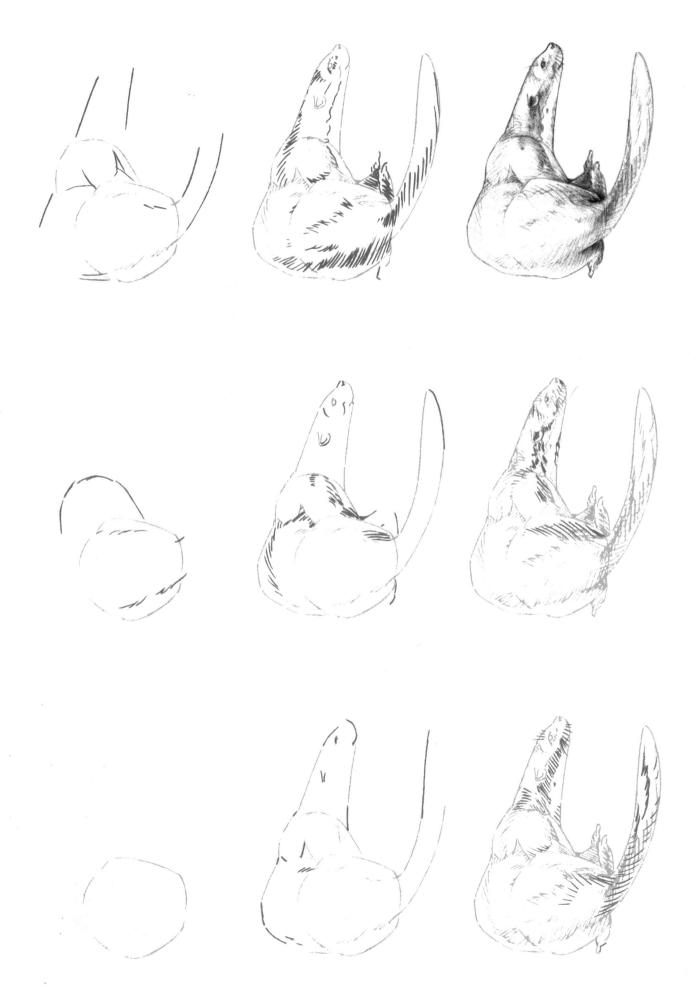

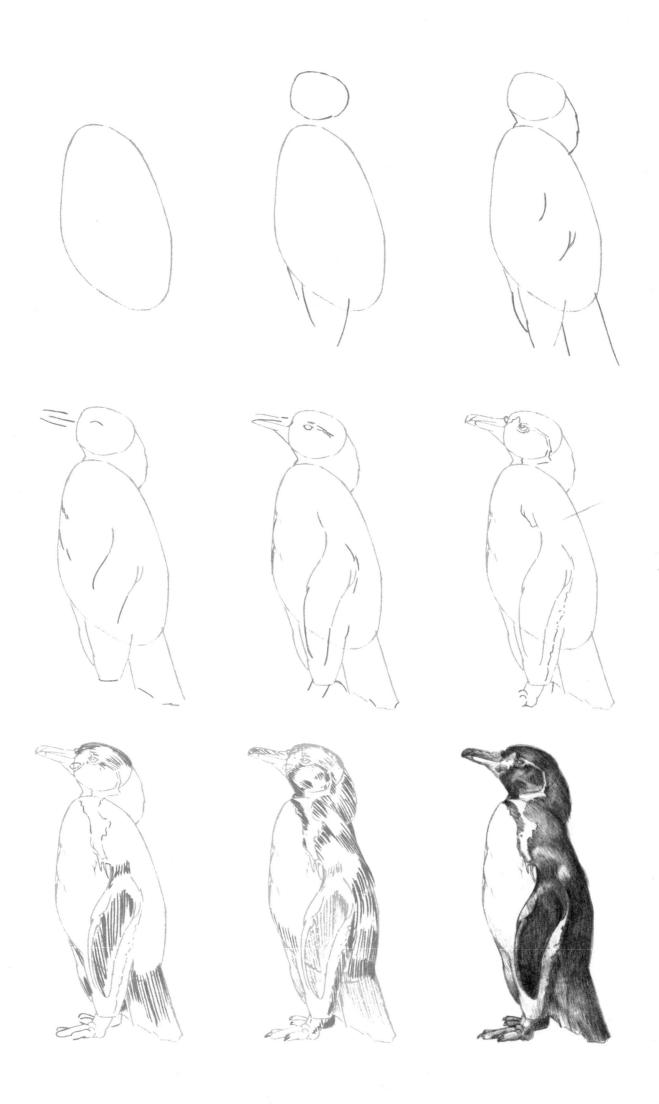

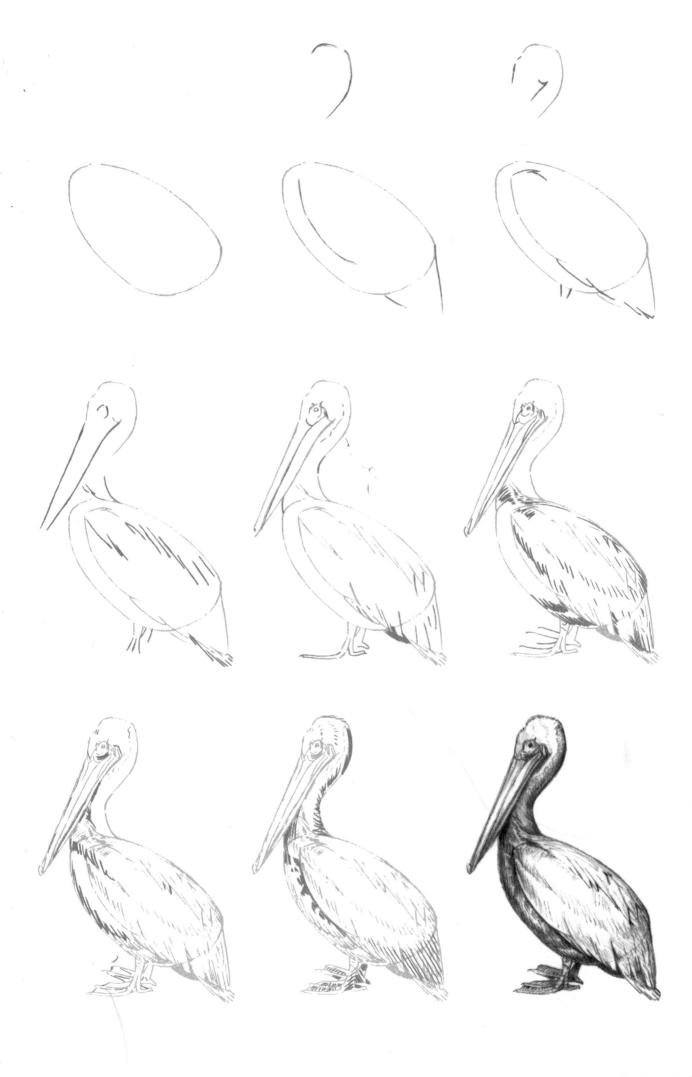

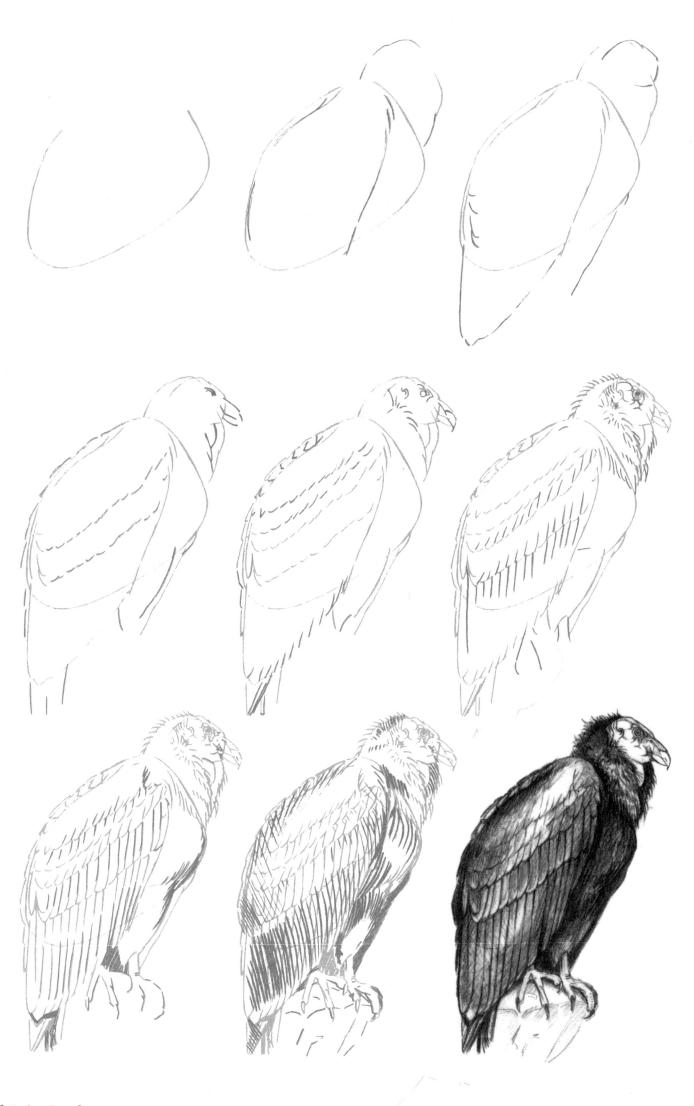

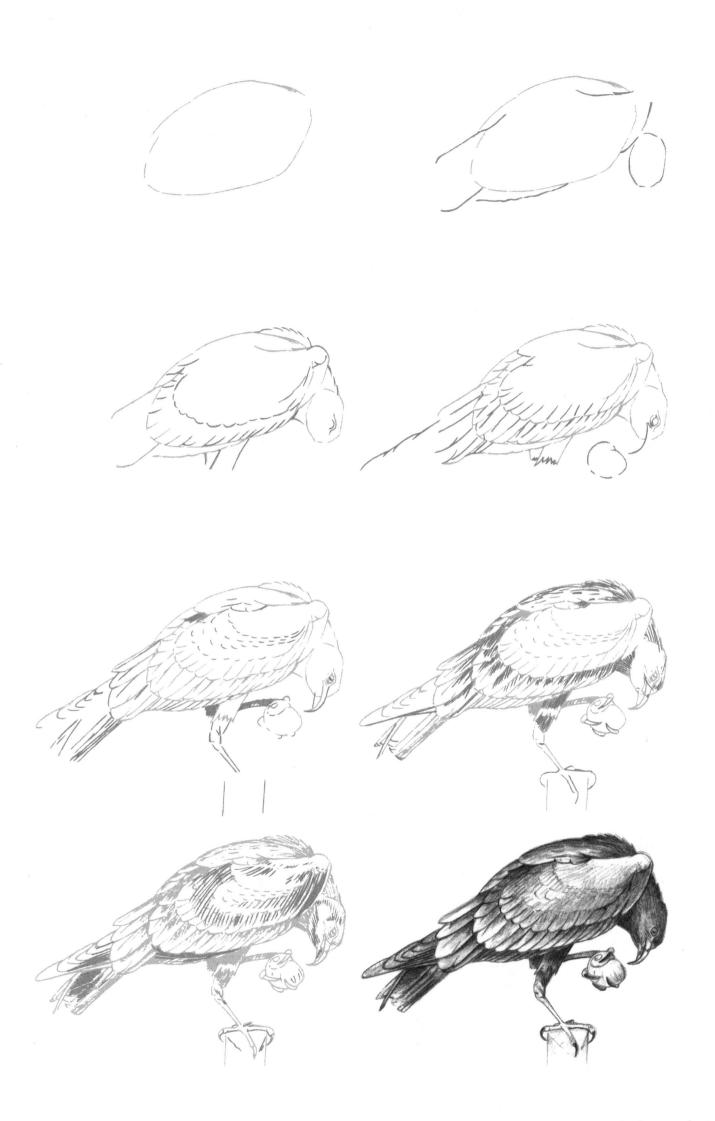

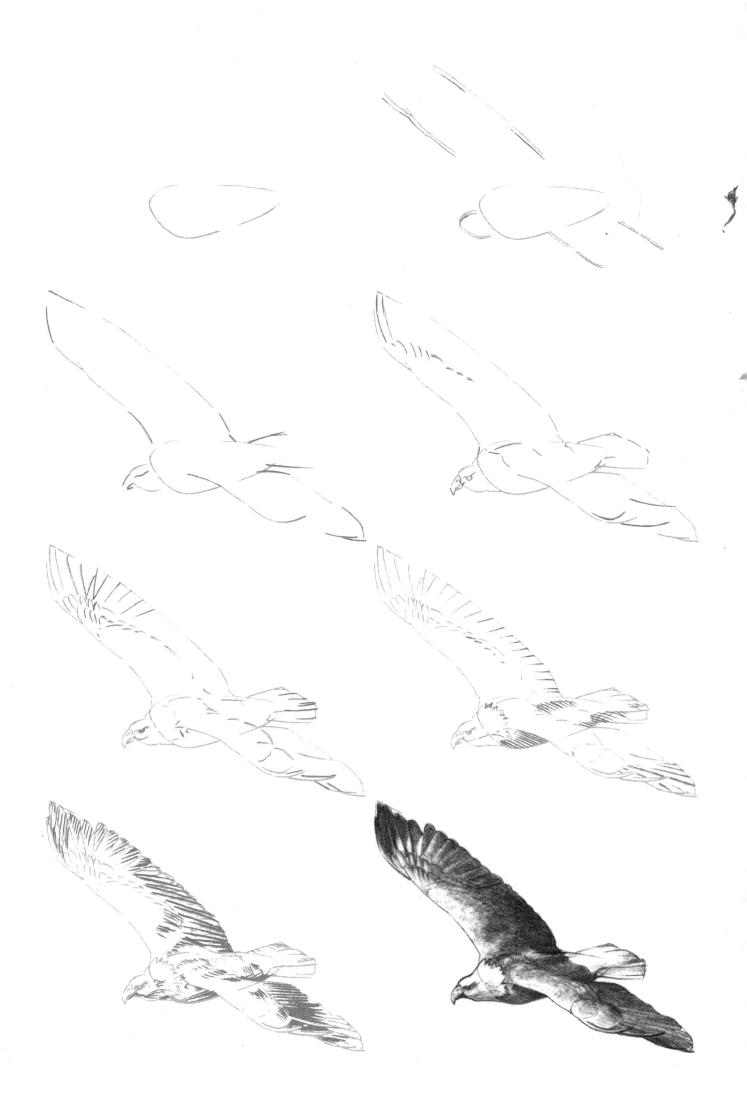

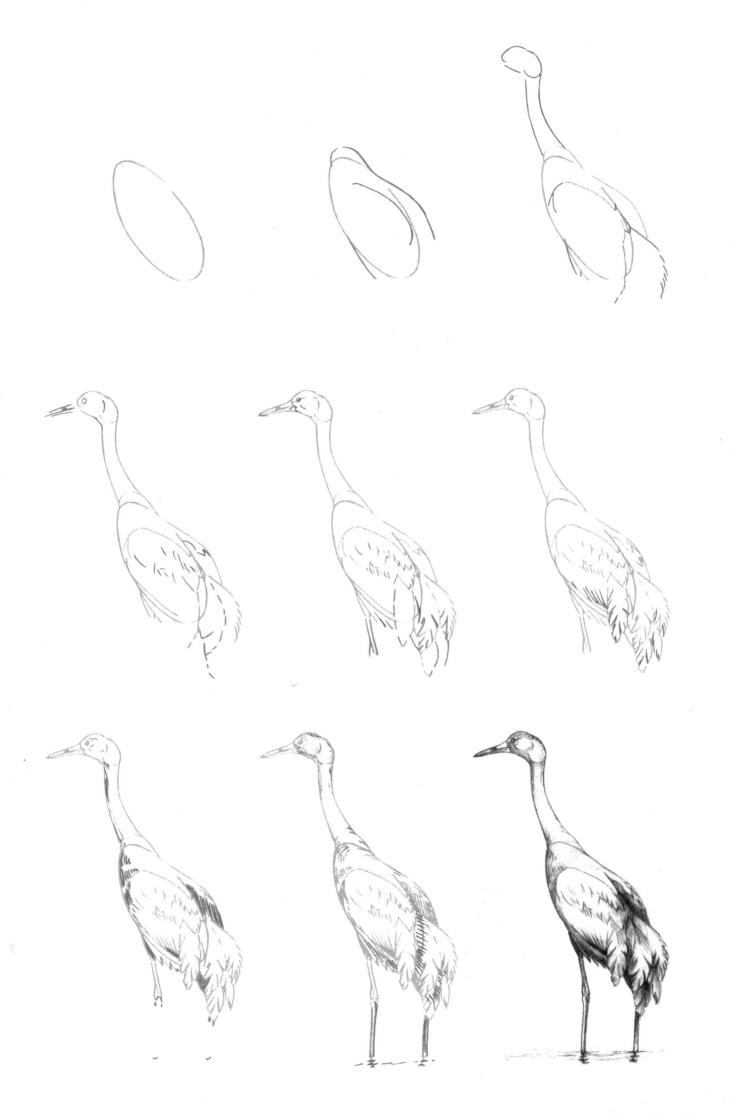

Whooping Crane

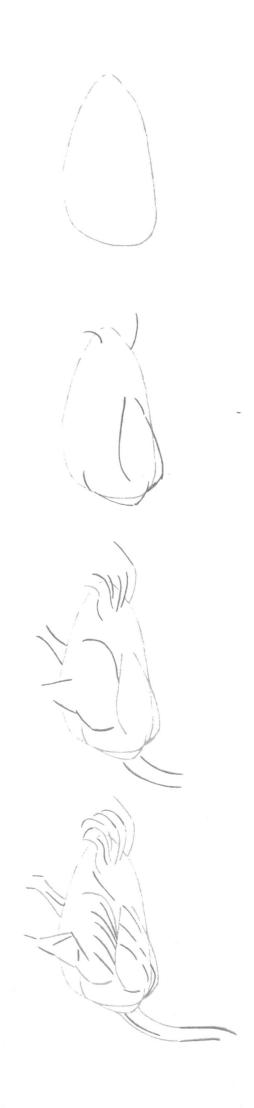

Virginia Big-Eared Bat

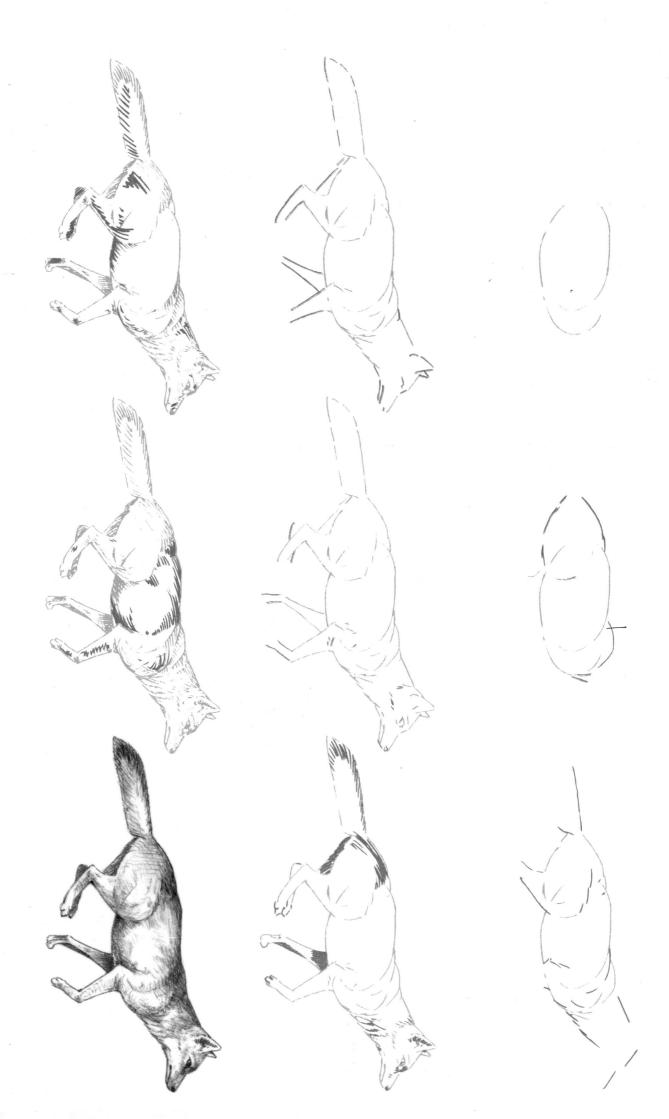

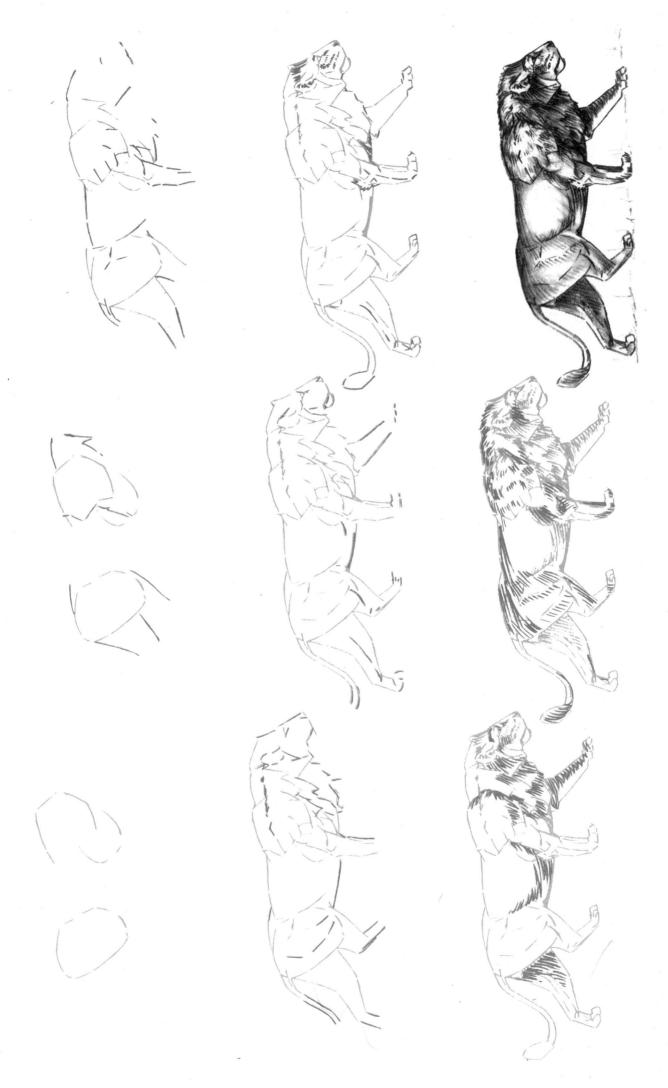

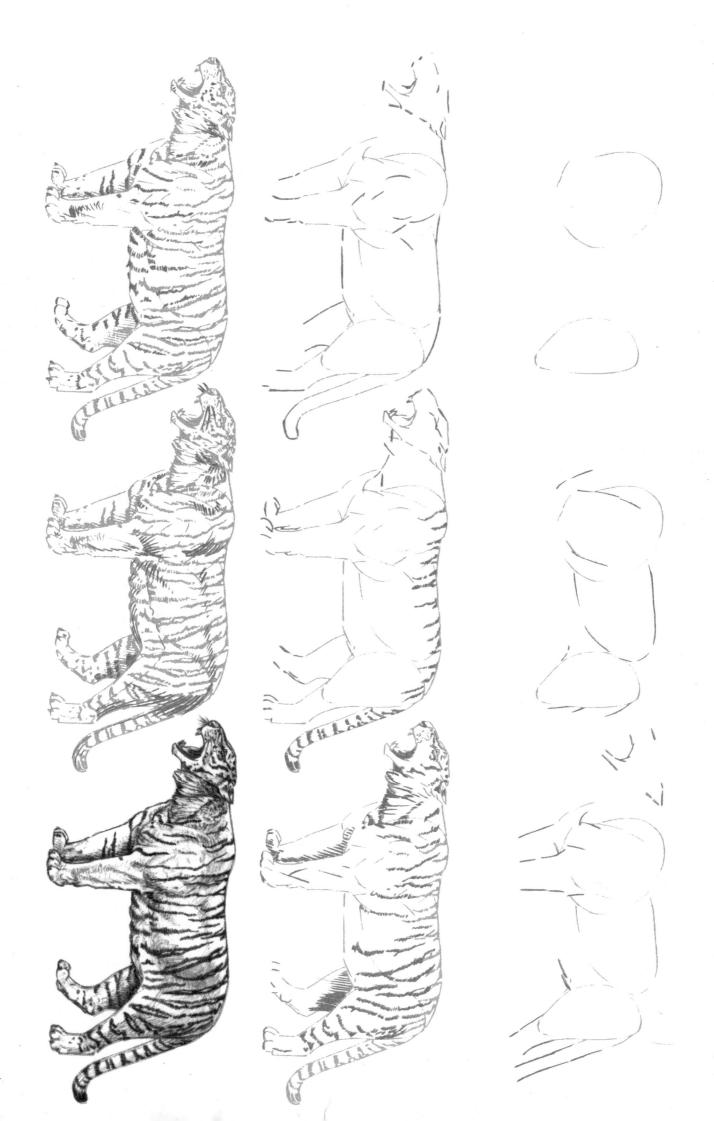

Siberian Tiger

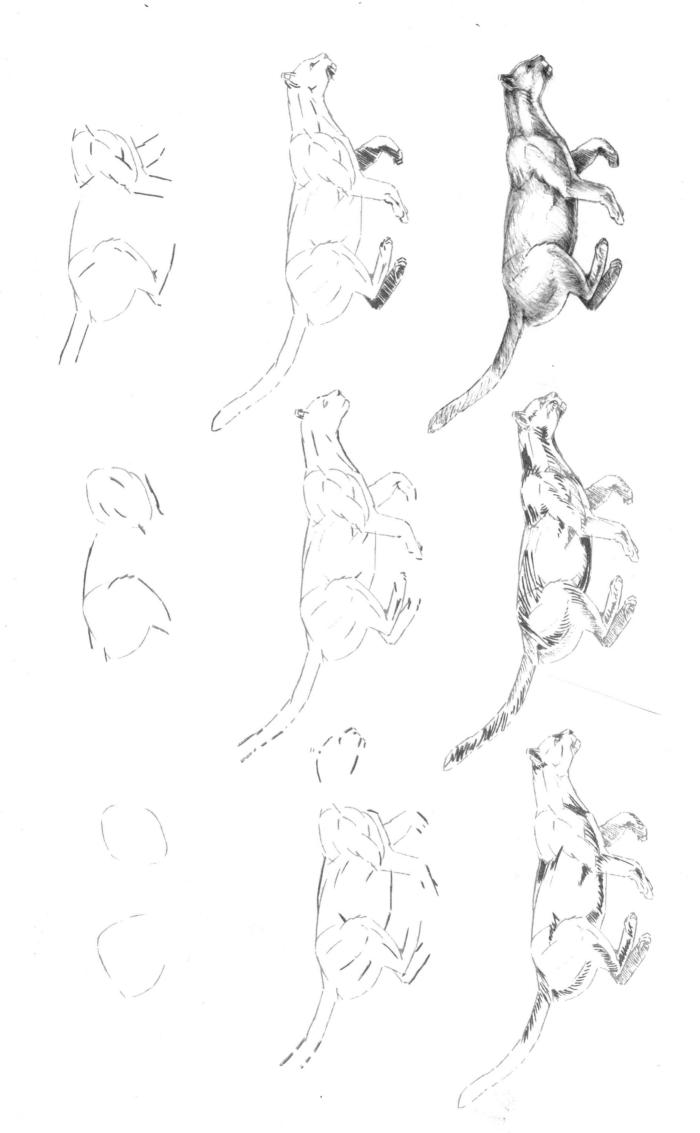

Eastern Cougar

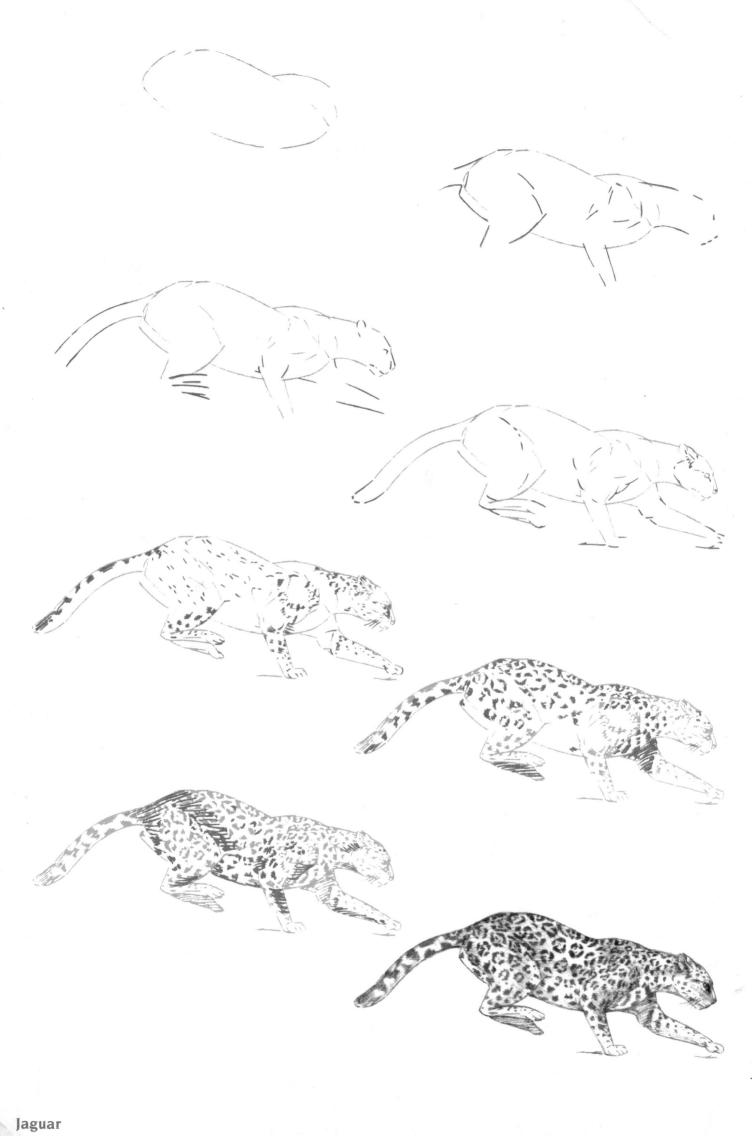

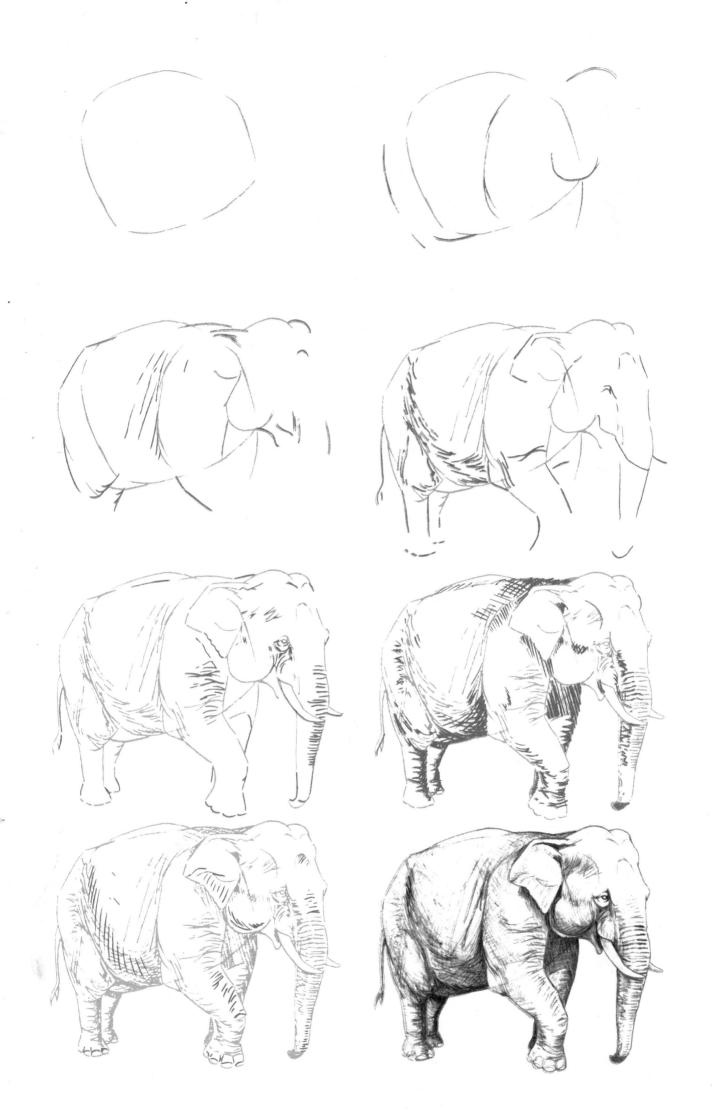

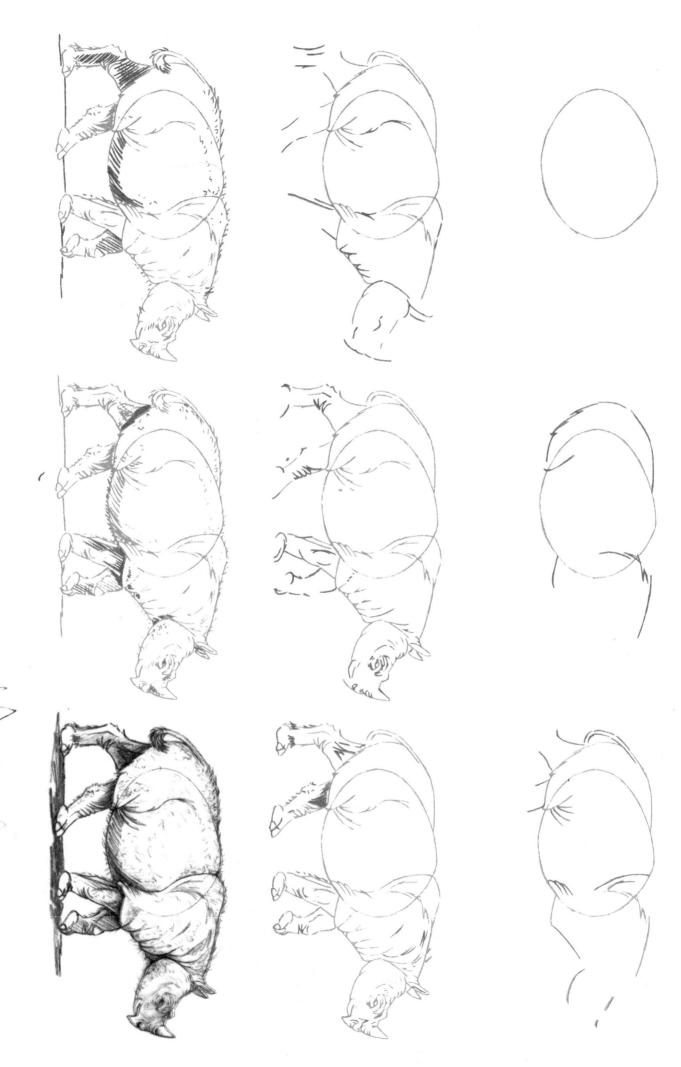

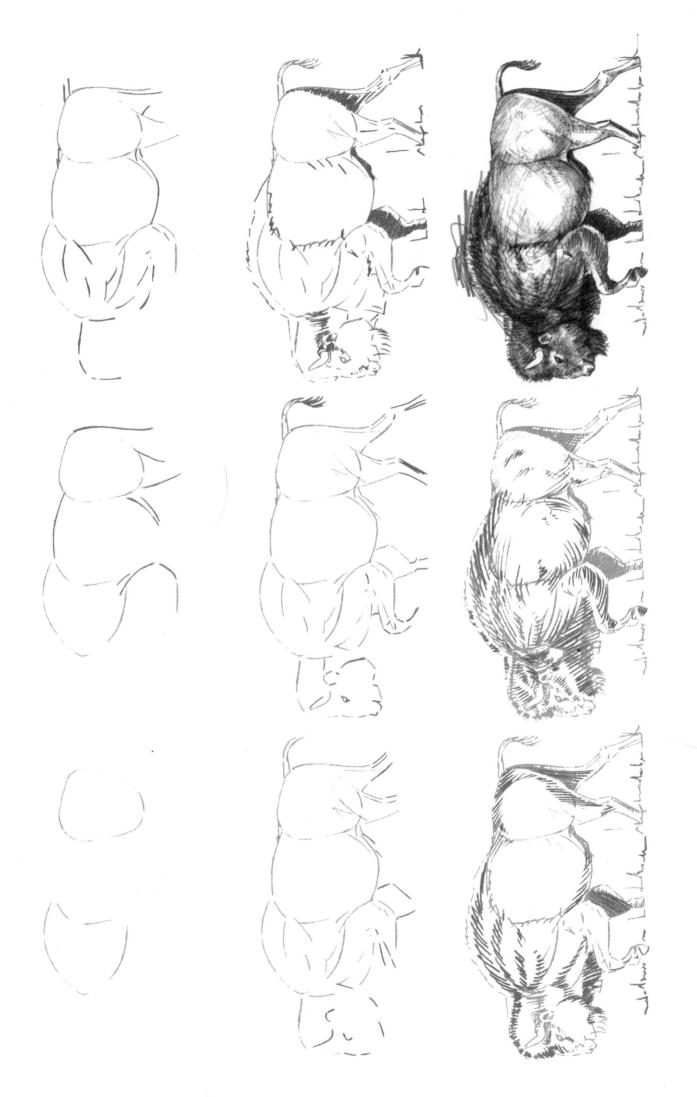

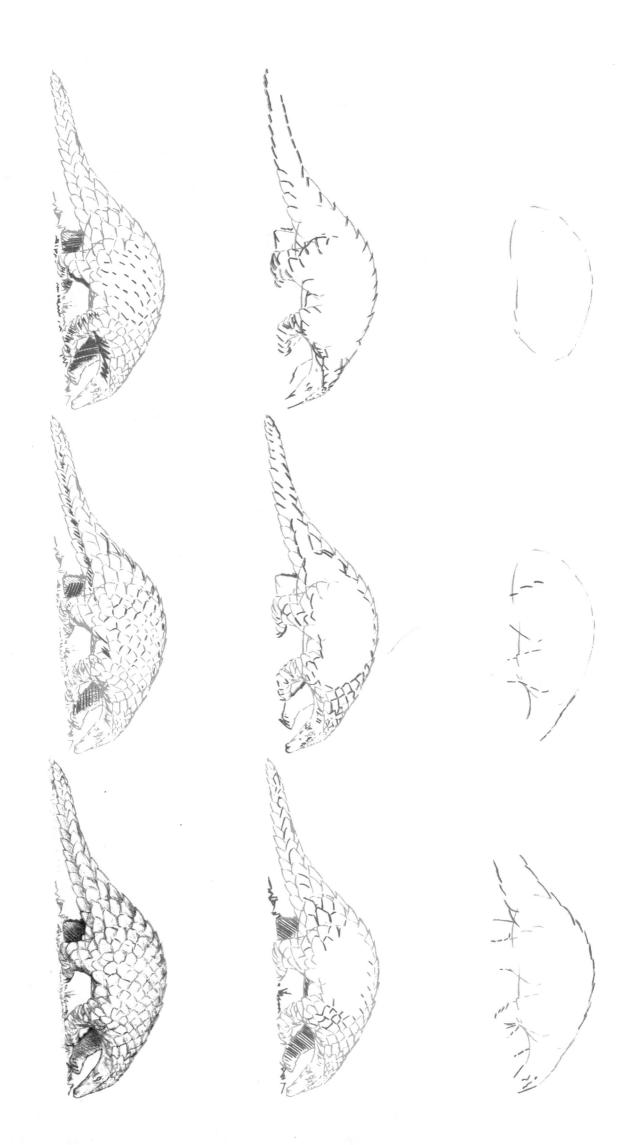

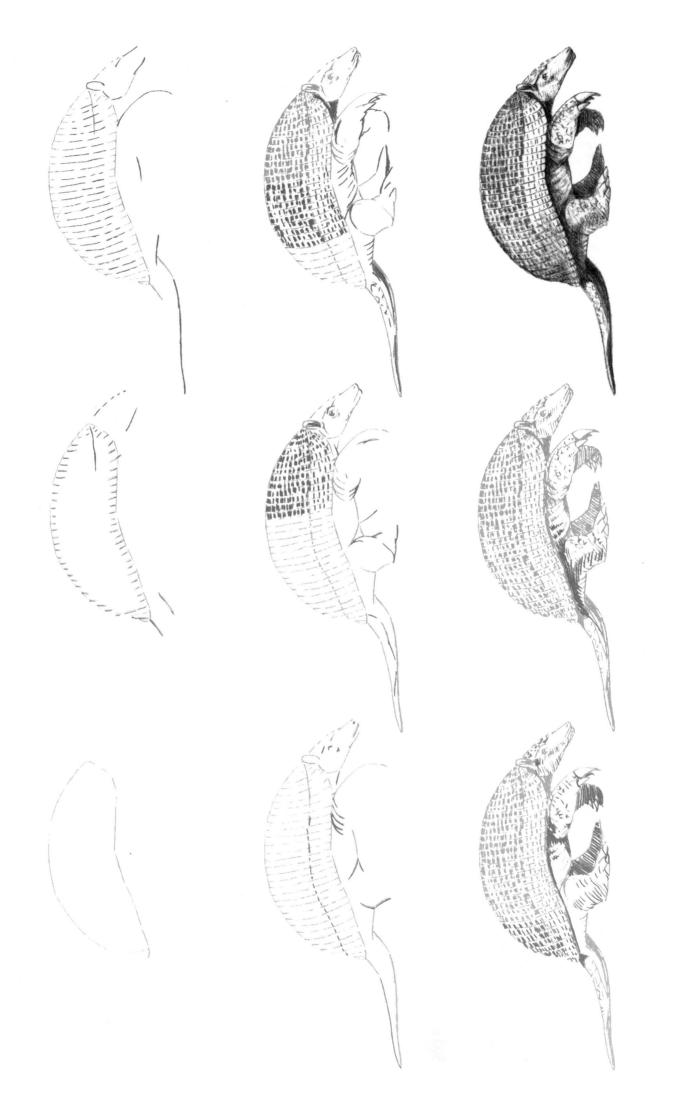

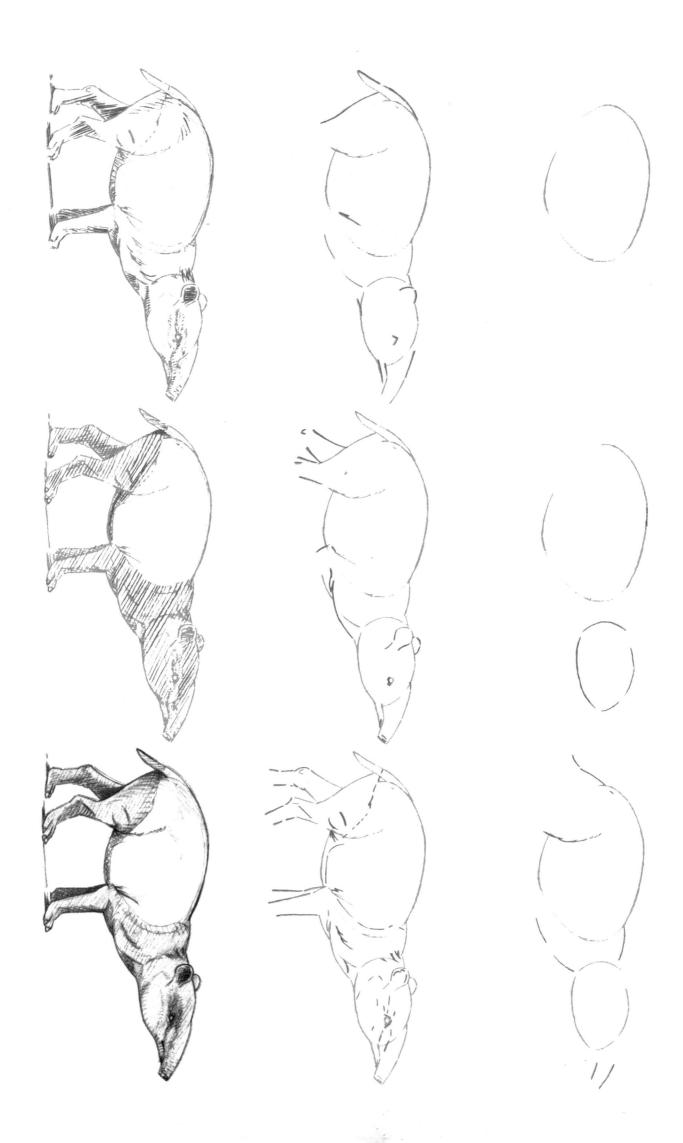

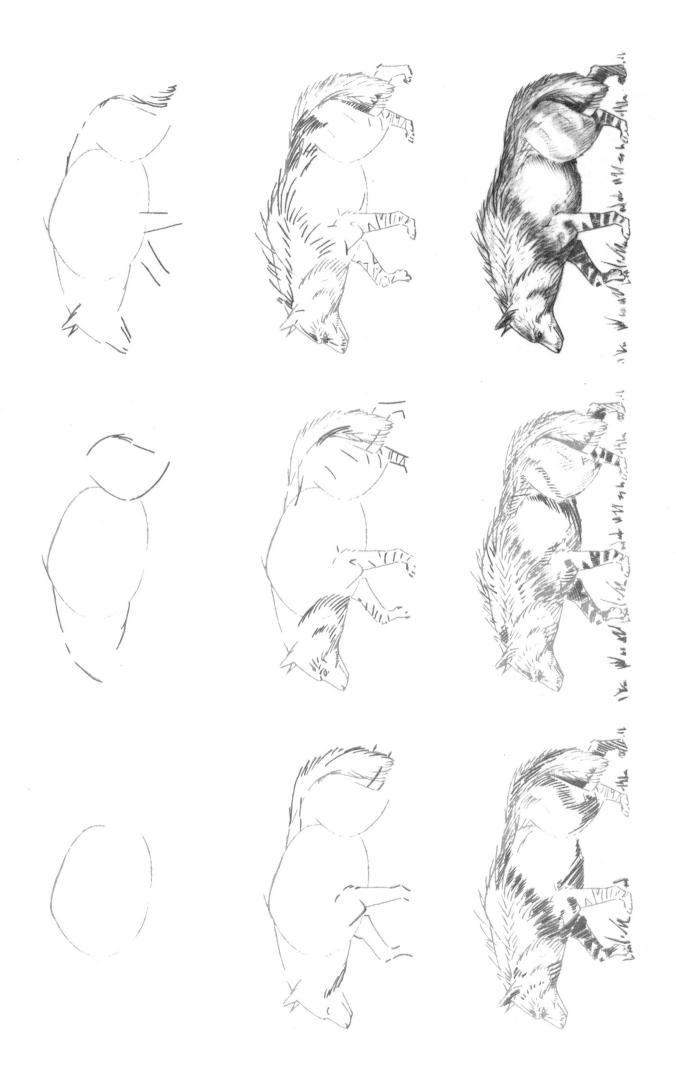

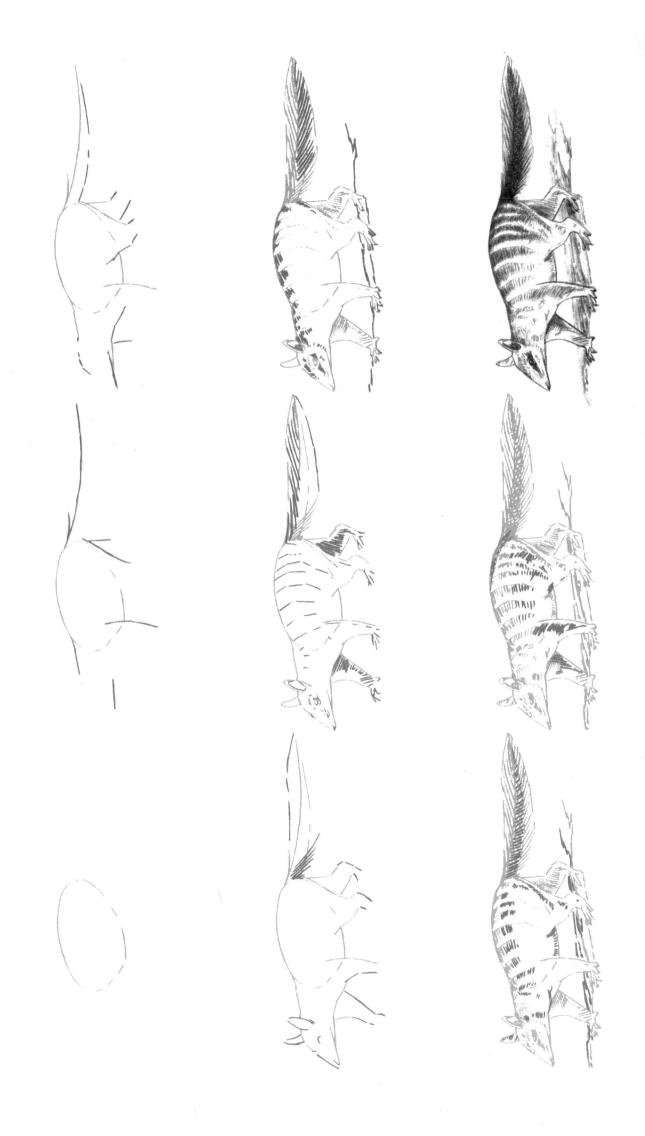

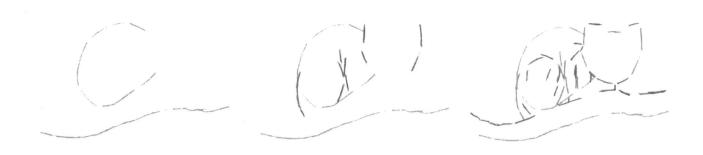

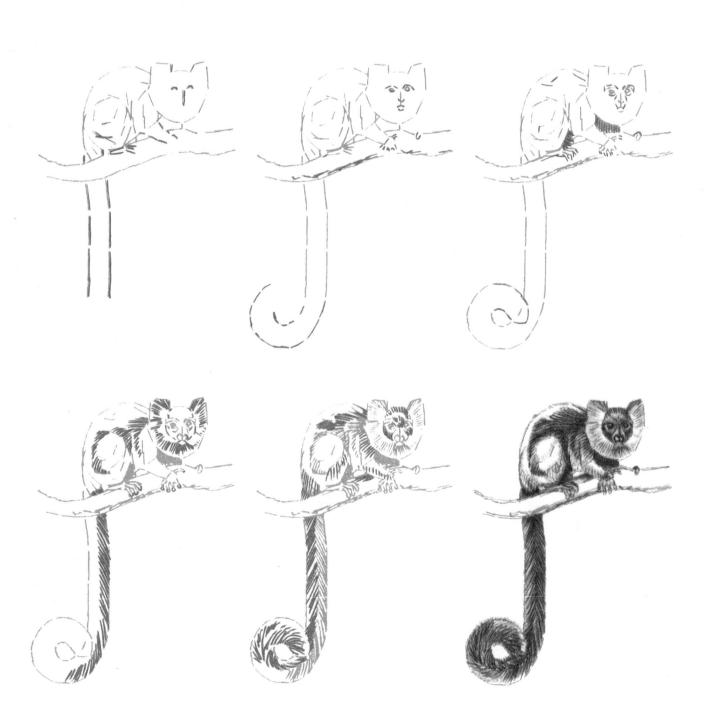

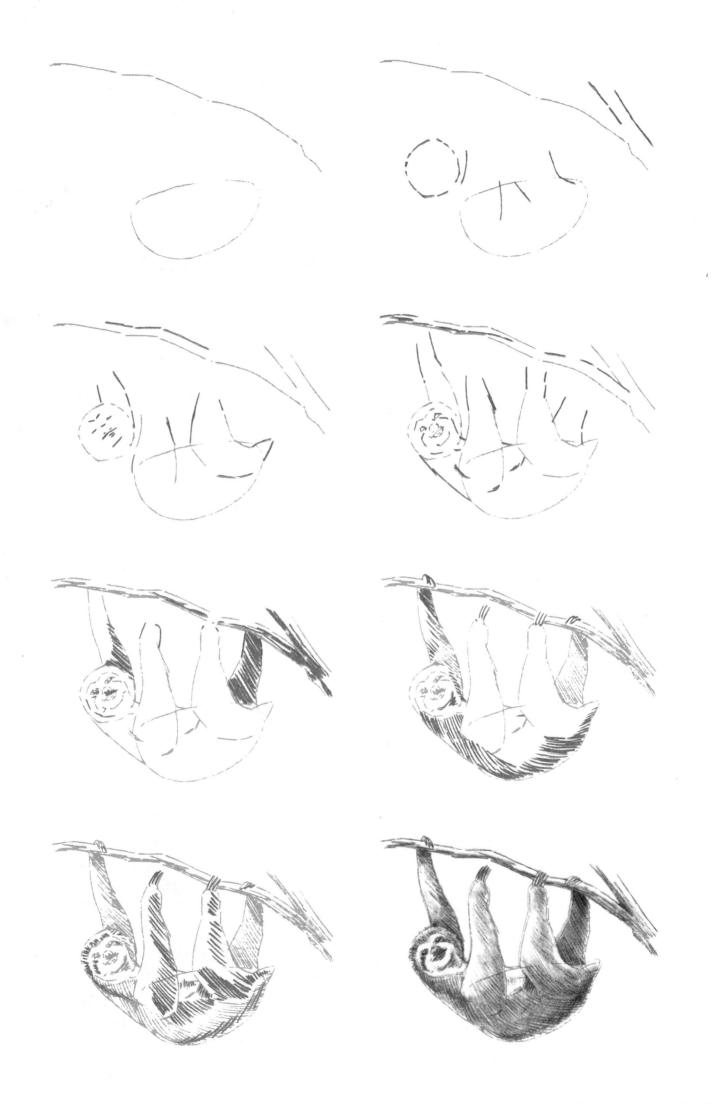

Brazilian Three-Toed Sloth

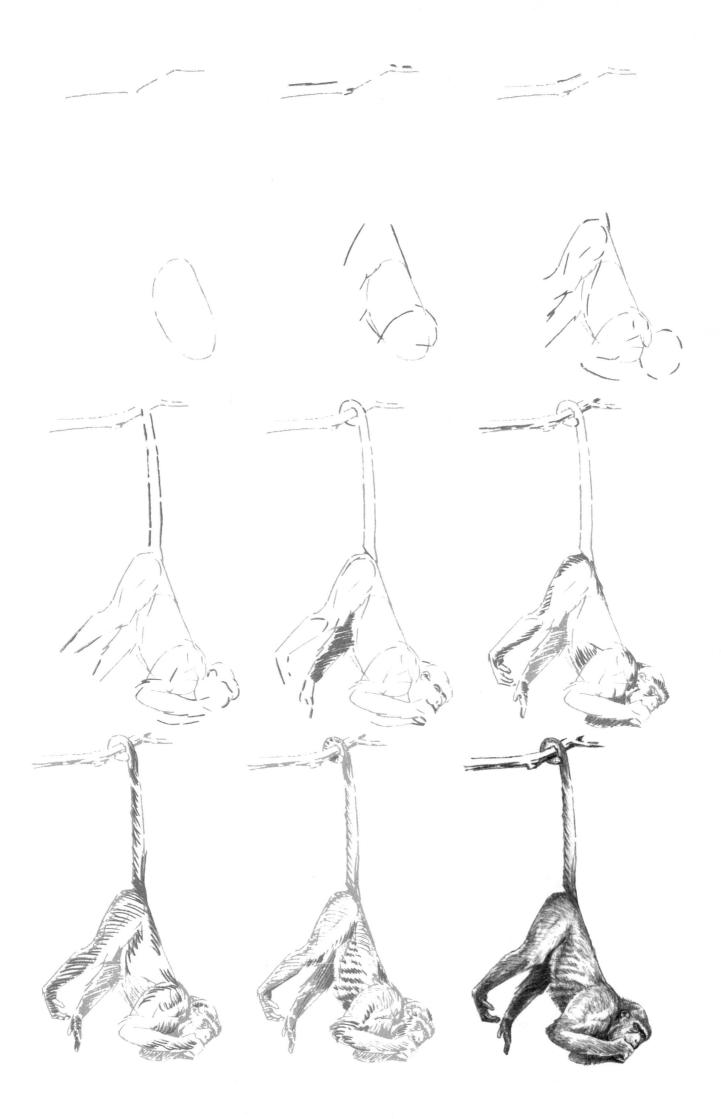

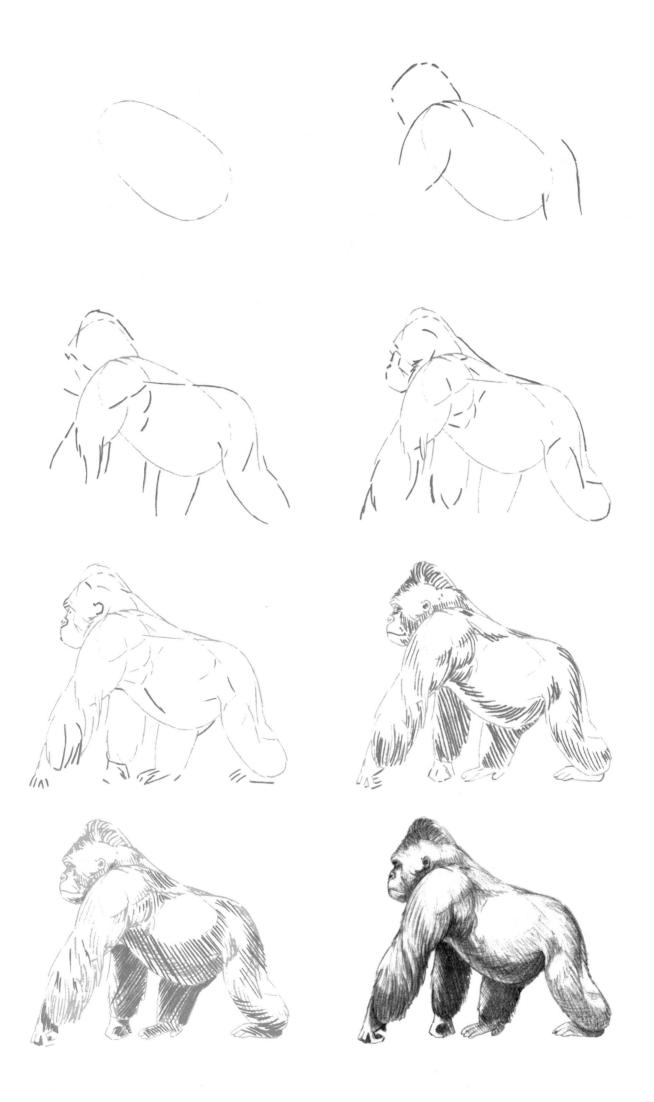

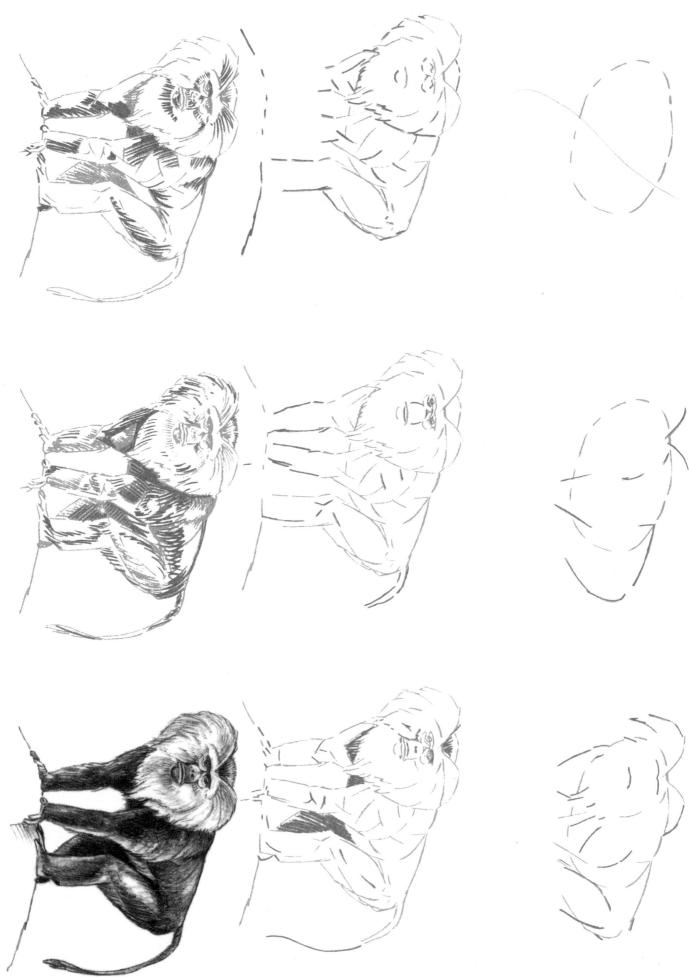

Lion-Tailed Macaque

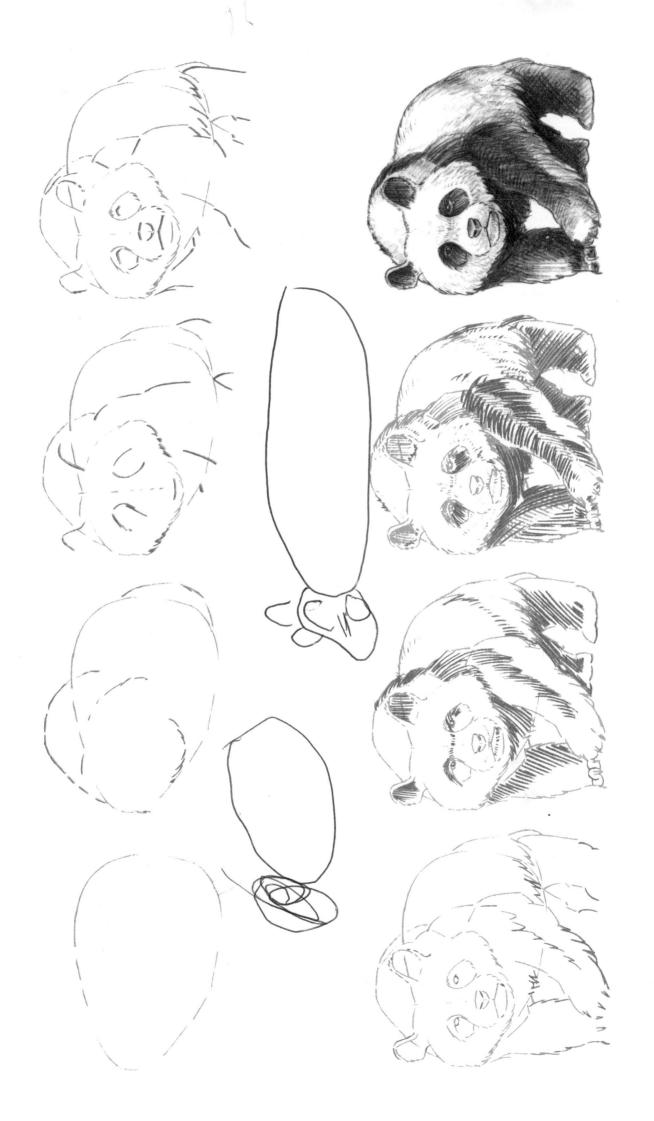

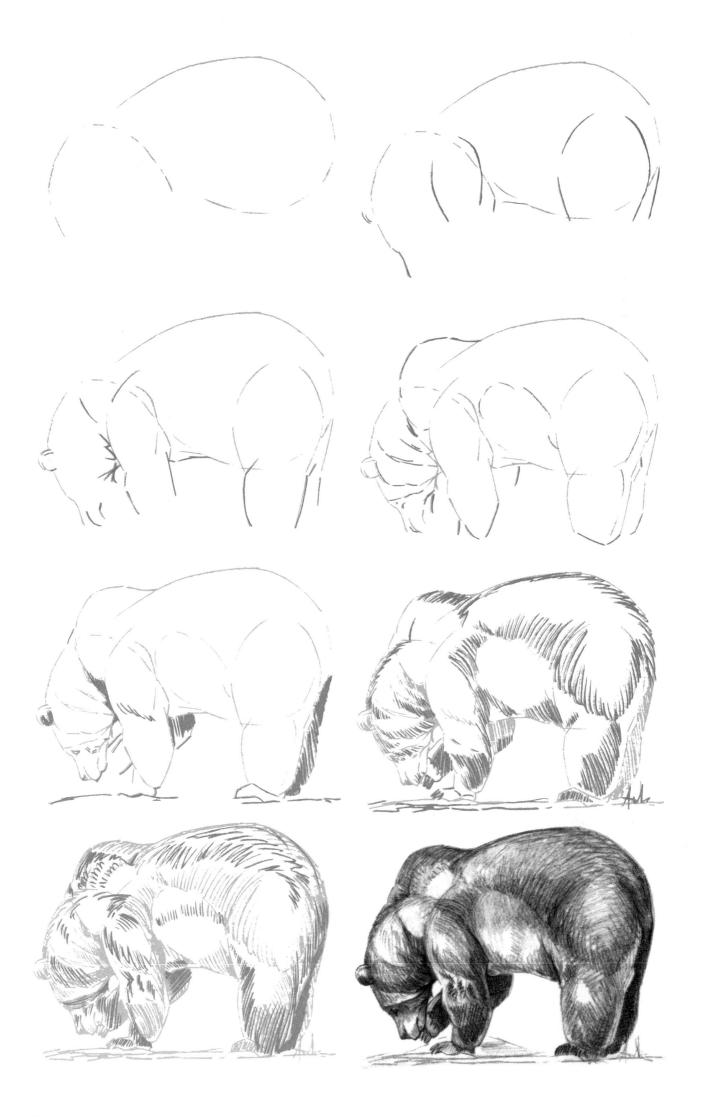

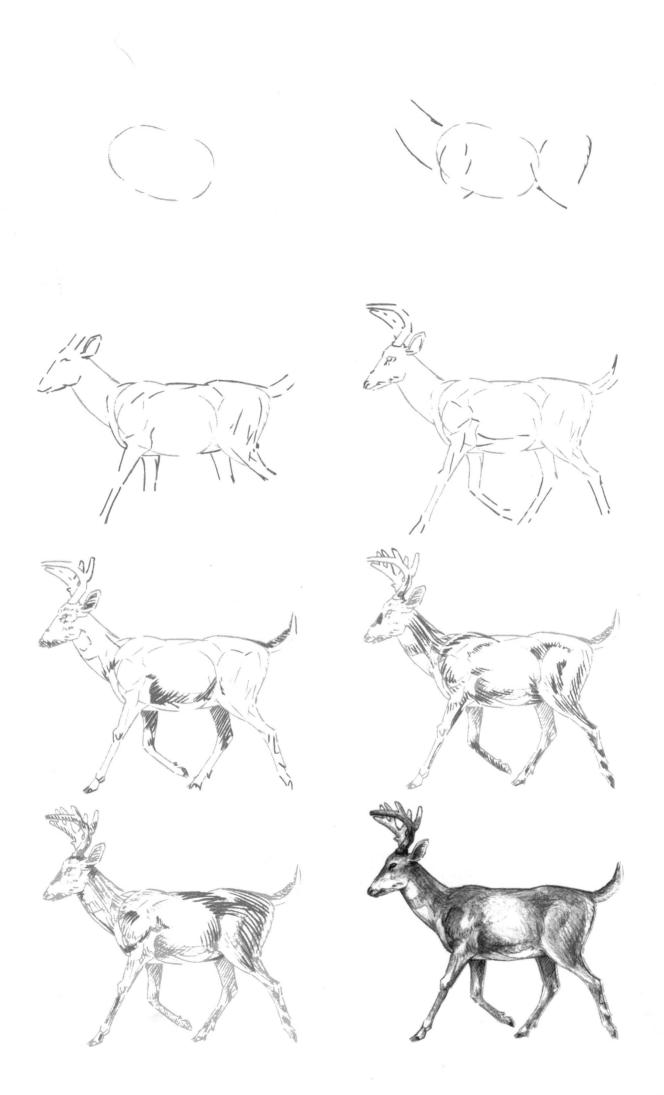

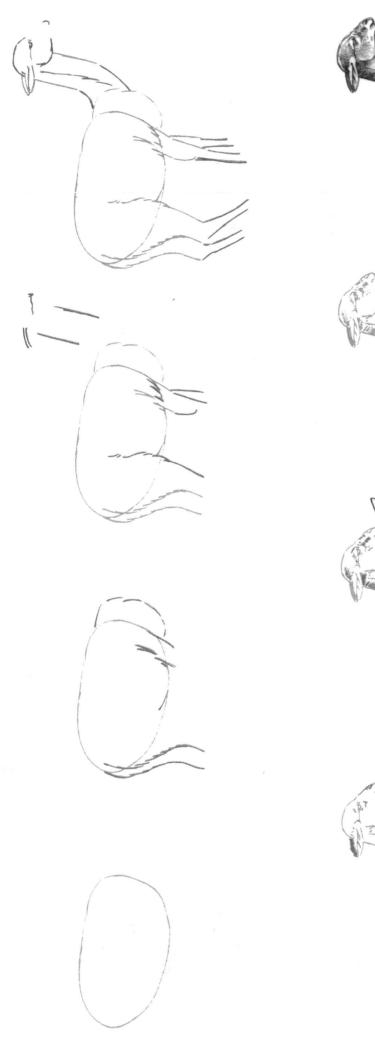

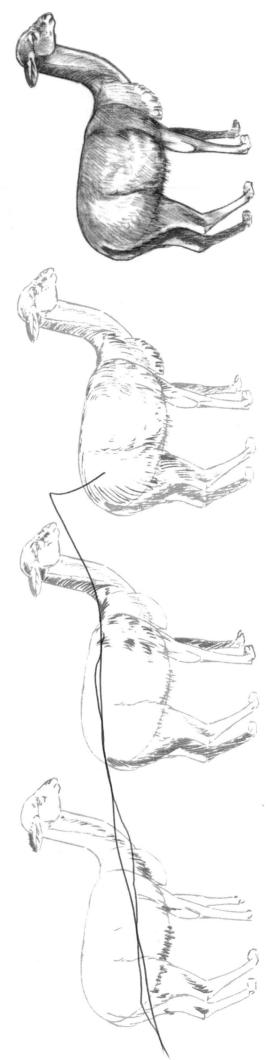

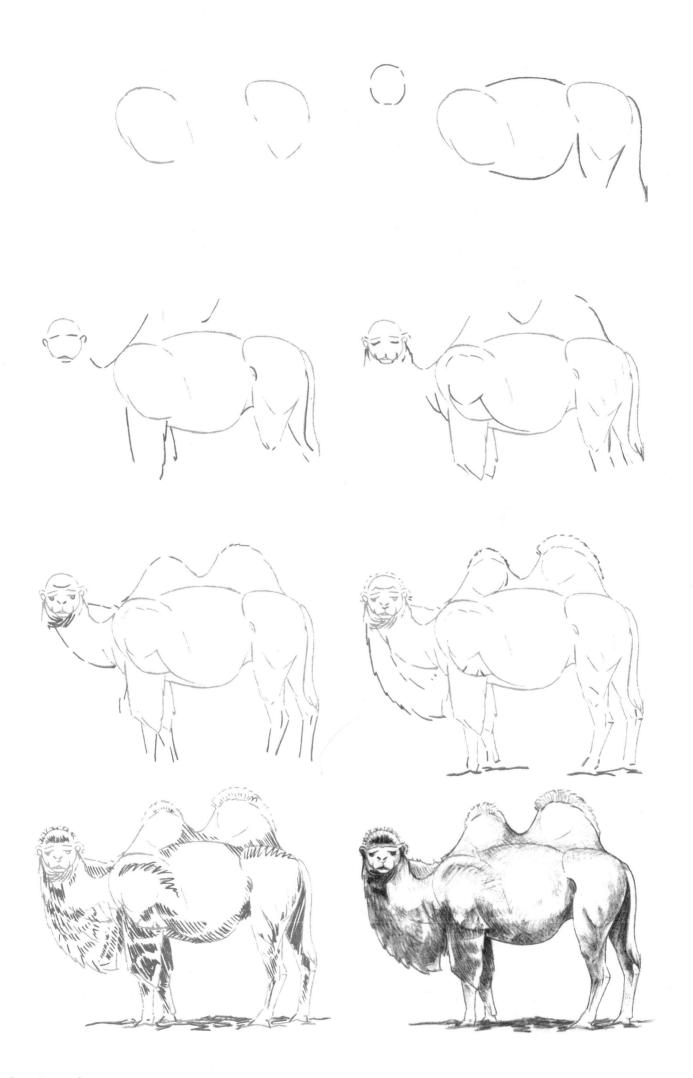

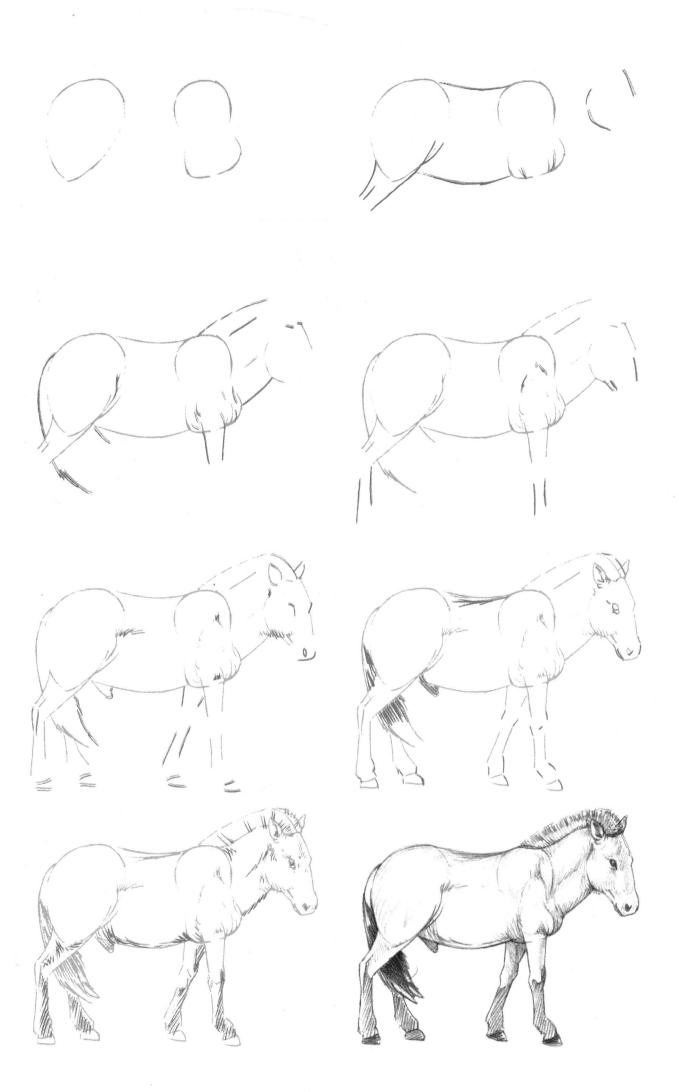

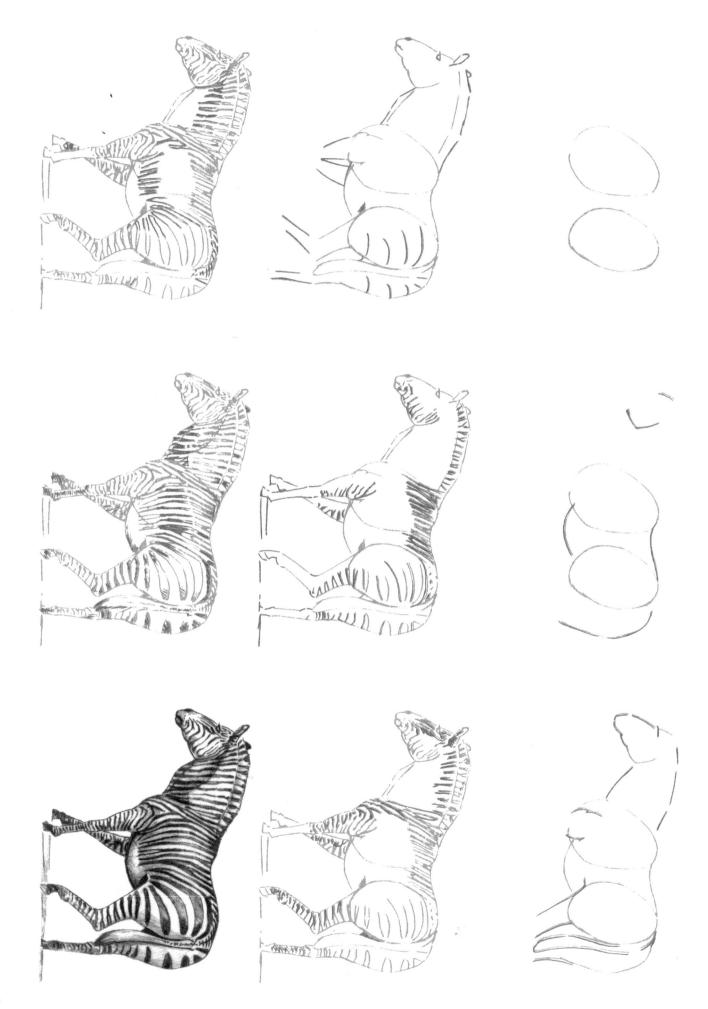

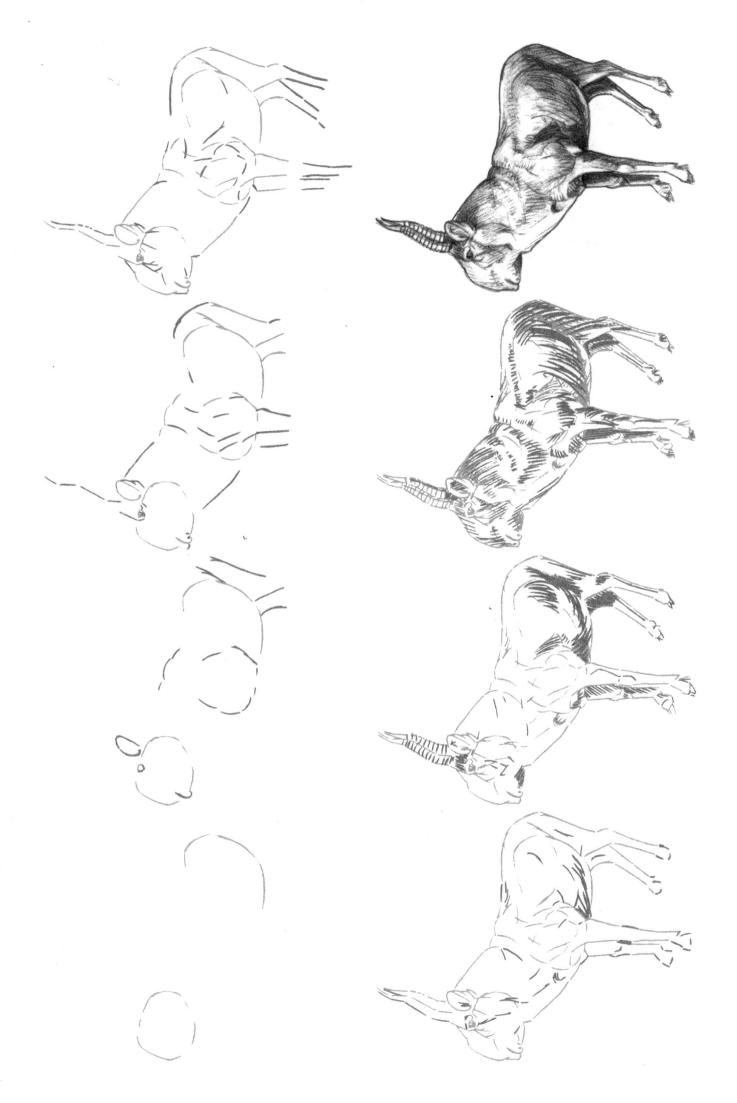

Saiga

Lee J. Ames has been "drawing 50" since 1974, when the first "Draw 50" title—Draw 50 Animals—was published. Since that time, Ames has taught millions of people to draw everything from dinosaurs and sharks to boats, buildings and cars. There are currently twenty titles in the "Draw 50" series, with nearly two million books sold.

Native Long Islander **Warren Budd** is a graduate of Southampton College and holds a bachelor's degree in fine arts. He has been illustrating books for over ten years, primarily in the natural science area. The artist lives in Patchogue, Long Island, with his wife and two children.

50 FOR HOURS OF FUN!

sep-by-step method of drawing instruction, you can easily learn to lanes, cars, sharks, buildings, dinosaurs, famous cartoons, and so of people have learned to draw by using the award-winning 'Draw 50'' technique. Now you can too!

COLLECT THE ENTIRE DRAW 50 SERIES!

Series books are available from your local bookstore. You may also order direct opy of this form to order). Titles are paperback, unless otherwise indicated.

	TITLE	PRICE	QTY	TOTAL
	Airplanes, Aircraft, and Spacecraft	\$8.95/\$11,95 Can	× =	=
X-contract	Aliens	\$8.95/\$11.95 Can	× =	=
19519-2	Animals	\$8.95/\$11.95 Can	× =	=
24638-2	Athletes	\$8,95/\$11.95 Can	× =	=
26767-3	Beasties and Yugglies and Turnover			
	Uglies and Things That Go Bump in	¢0.05/¢11.05.0		
471427	the Night	\$8.95/\$11.95 Can	× =	
47163-7		\$8.95/\$11.95 Can	× =	
	Birds (hardcover)	\$13.95/\$18.95 Can	× =	
	Boats, Ships, Trucks, and Trains	\$8.95/\$11.95 Can	× =	
	Buildings and Other Structures	\$8.95/\$11.95 Can	× =	
	Cars, Trucks, and Motorcycles	\$8.95/\$11.95 Can	× =	
24640-4		\$8.95/\$11.95 Can	× =	
	Creepy Crawlies	\$8.95/\$11.95 Can	× =	
19520-6	Dinosaurs and Other Prehistoric Animals	¢0.05/¢11.05.0		
23431-7		\$8.95/\$11.95 Can \$8.95/\$11.95 Can	× =	
	Endangered Animals	\$8.95/\$11.95 Can	× =	
	Famous Cartoons	\$8.95/\$11.95 Can	× =	
	Famous Faces	\$8.95/\$11.95 Can	× =	
	Flowers, Trees, and Other Plants	\$8.95/\$11.95 Can	× =	
	Holiday Decorations	\$8.95/\$11.95 Can	× =	
17642-2			× =	
17639-2		\$8.95/\$11.95 Can \$8.95/\$11.95 Can	× =	
41194-4			× =	
	People of the Bible	\$8.95/\$11.95 Can \$8.95/\$11.95 Can	× =	
	People of the Bible (hardcover)		× =	
	Sharks, Whales, and Other Sea	\$13.95/\$19.95 Can	× =	
207 00-1	Creatures	\$8.95/\$11.95 Can	× =	
14154-8		\$8.95/\$11.95 Can	× =	
	Shipping and handling	(add \$2.50 per order		
		TOTAL	/^ —	
		I O IAL		

Please send me the title(s) I have indicated above. I am enclosing \$_____

Send check or money order in U.S. funds only (no C.O.D.s or cash, please). Make check payable to Random House, Inc. Allow 4–6 weeks for delivery. Prices and availability subject to change without notice.

Name:			
Address:	ž		Apt. #
City:	ī	267	State: Zip:

Send completed coupon and payment to:

Random House, Inc. Customer Service 400 Hahn Rd. Westminster, MD 21157